Published by Creative Education
123 South Broad Street, Mankato, Minnesota 56001
Creative Education is an imprint of The Creative Company

Designed by Stephanie Blumenthal

Photographs by James Blank, Richard Cummins, Bob Ecker, Richard Nowitz,
Photri (Dorian Weber), Lee Snider, Jonathan Wallen

Library of Congress Cataloging-in-Publication Data

Koelsch, Patrice.
Museums / by Patrice Koelsch.
p. cm. — (Designing the future)
Includes index.
ISBN 1-58341-132-1
1. Art museums–Juvenile literature.
2. Museums–Juvenile literature.
[1. Museums.] I. Title. II. Series.
N410 .K64 2001
708–dc21 00-064473

First Edition

9 8 7 6 5 4 3 2 1

*Cover, the Smithsonian's
Natural History Museum;
p. 1, sculpture detail;
p. 2, the Prado;
p. 3, the Rock and
Roll Hall of Fame
and Museum*

MUSEUMS

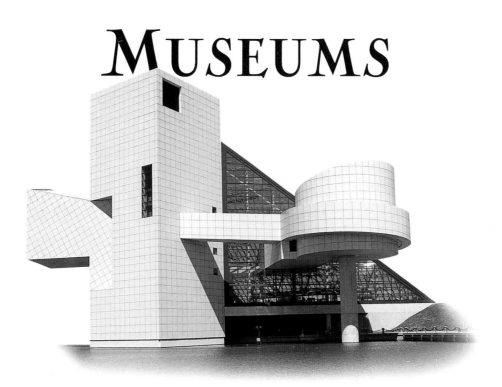

PATRICE KOELSCH

CREATIVE C EDUCATION

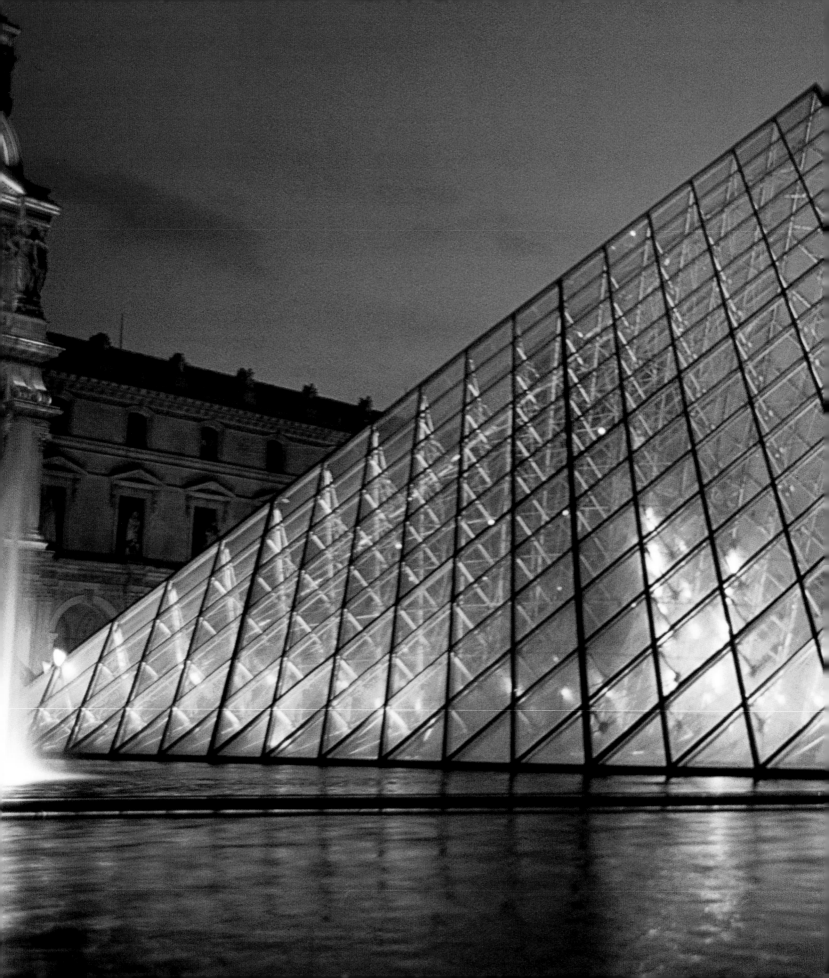

Throughout history, human beings have displayed and discussed objects that are important to them in spaces called museums: art museums, natural history museums, air and space museums, science museums, and even museums dedicated to such things as volcanoes and rock and roll. The amazing variety of museums raises two questions: Is there anything that all museums have in common? And what exactly is a museum? To figure out the answers, it helps to understand the history of museums.

Glass pyramid entrance to the Louvre in Paris, France

Tate Gallery, London, England

The word "museum" comes from the Greek word *muse*. In Greek mythology, the muses were the patron goddesses of history, astronomy, and all the arts. From their very beginnings in the ancient world, museums were places that encouraged the preservation and study of significant objects from art, history, culture, and science. Their spaces were dedicated to the muses.

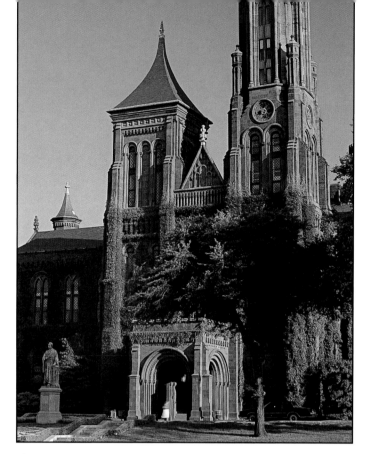

The original Smithsonian Institution building

The ancient ancestors of modern museums were temples. Statues, painted vases, precious metals, rare objects, and war trophies were often displayed in temples to honor the gods and to invoke the gods' protection for the treasures.

The first real museum was the great library at Alexandria, in Egypt, which was a huge building constructed 2,300 years ago to house hundreds of thousands of scrolls—the books of that period—on Greek literature, philosophy, and science. This library, called the Mousion (MYOU-zee-on), was designed so that scholars examining the scrolls would be surrounded by inspiring examples of

When the original Smithsonian building opened, some viewers appreciated what one scholar called its "picturesque asymmetry," but the social reformer Dorothea Dix wasn't impressed. She called it "a monstrous pile of misshapen towers, arches, columns."

sculpture and painting. For nearly 800 years, the best mathematicians and astronomers in the Western world gathered in Alexandria to work at the Mousion. Sadly, the library was completely burned in the fifth century by Christian zealots who wanted to destroy pagan learning.

During the Middle Ages, in much of Europe, valuable and unusual objects were often stored in abbeys and monasteries. Some of these were religious objects made of precious metals and gems, but monastery collections might also have included such rarities as ostrich eggs, leopard skins, sea shells, or the lance-like tusk of a narwhal, a small arctic whale, which was mistaken for the magical horn from the mythical unicorn.

About 500 years ago, during the Italian Renaissance, wealthy families commissioned, collected, and displayed ornate paintings, sculptures, and armaments in their homes. Artists were also paid to create paintings and sculptures for churches. One famous example is Michelangelo's painting *The Last Judgment* on the ceiling of the Sistine Chapel. The Sistine Chapel is now part of the vast Vatican Museum complex in Rome.

Sculpted pillar outside the Chicago Field Museum

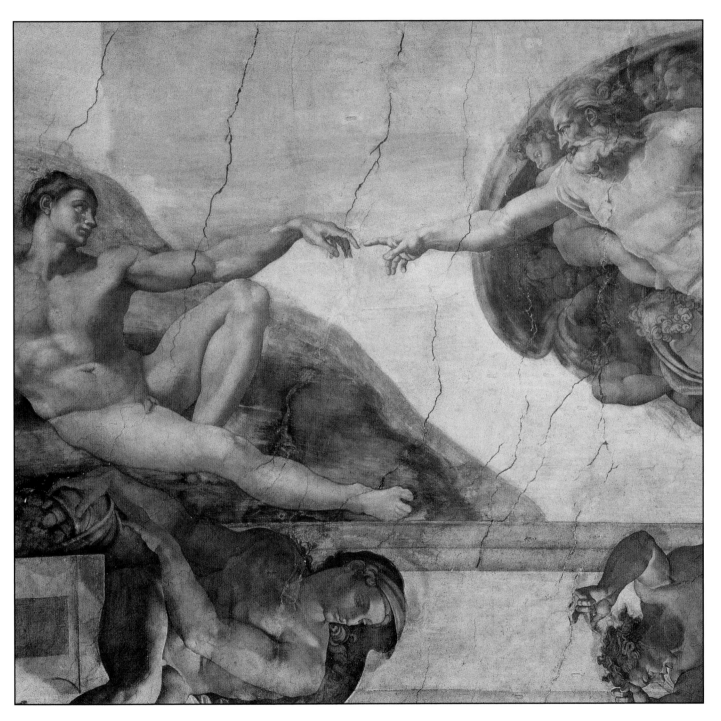

Michelangelo's The Last Judgment, *preserved in the Sistine Chapel*

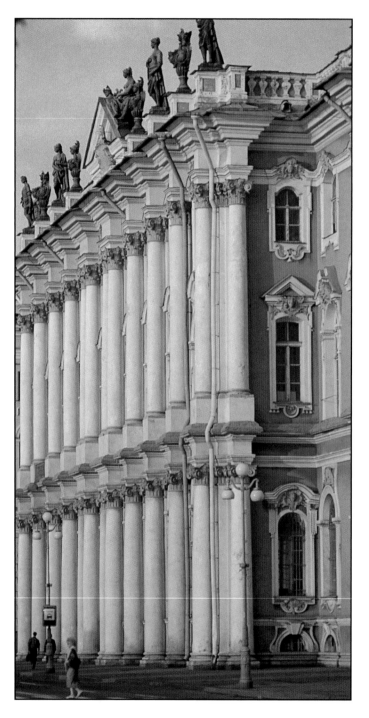

The royal Winter Palace in St. Petersburg, Russia

Throughout the 16th and 17th centuries, European kings, queens, and princes decorated their palaces with paintings, tapestries, and statues. Prosperous merchants collected not only paintings but also such natural objects as unusual stones and skulls, tusks and horns, or knots of wood that resembled human or animal faces. These collections were often kept in a special room called a *Wunderkammer* (VOON-der-cam-er), which means "chamber of wonders." In China and Japan, nobility also collected paintings, fine furniture, and beautiful ceramics to decorate their homes. In these countries, as in Europe, monasteries and temples were often storehouses for beautiful statues and other treasured works of art.

As a result of the French Revolution in 1793, the Louvre in Paris became the first public museum in

Europe. The French common people overthrew the monarchy and opened the royal palace and its art collection to anyone who wanted to see it. Over time, the building underwent many changes. It is now entered through a giant—and very modern—glass pyramid in its courtyard, designed by the innovative architect I. M. Pei.

The Louvre has more than 300,000 works of art in its collection, including Leonardo da Vinci's painting *Mona Lisa* and the armless statue *Venus de Milo*. The Louvre specializes in art from ancient times to the middle of the 19th century. The building's French Renaissance style of architecture is vast and heavy, suggesting the breadth and weight of the Louvre's collection.

Another museum in Paris, the Musée d'Orsay, is a good example of how a building constructed for

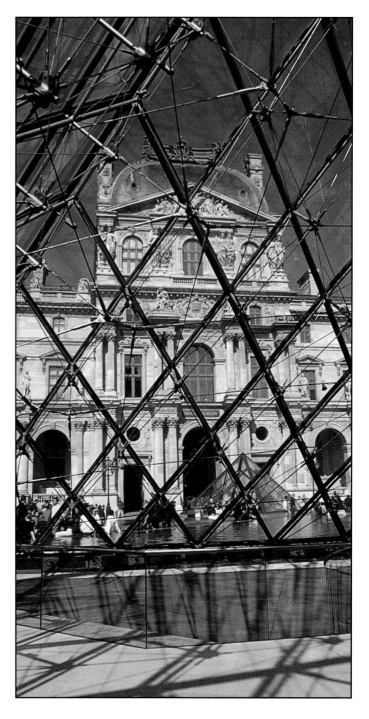

Looking out through the Louvre's glass pyramid

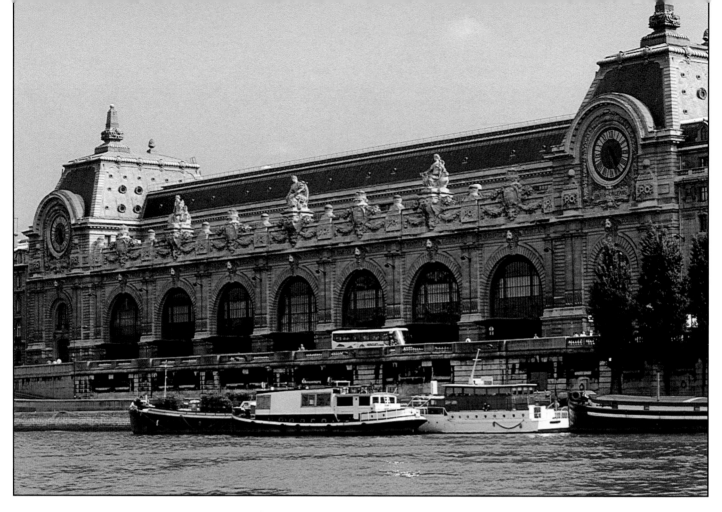

The Musée d'Orsay, a former train station in Paris

one use can be remodeled to serve a different purpose. The museum was built in 1900 as a train station, but the building fell into disuse in the 1940s and was almost torn down. The museum displays art created between the middle of the 19th century and the beginning of the First World War. The Orsay is dominated by a long central skylight, and the museum still looks a lot like a grand urban train station. Like the Louvre, the building's style suggests the styles of art inside.

A third Parisian art museum whose architecture reflects its art is the

The Botanical Museum at Harvard University was founded in 1858. Originally called The Museum of Vegetable Products, it includes a collection of 3,000 scientifically accurate, life-sized glass models of plants, which were created between 1887 and 1930.

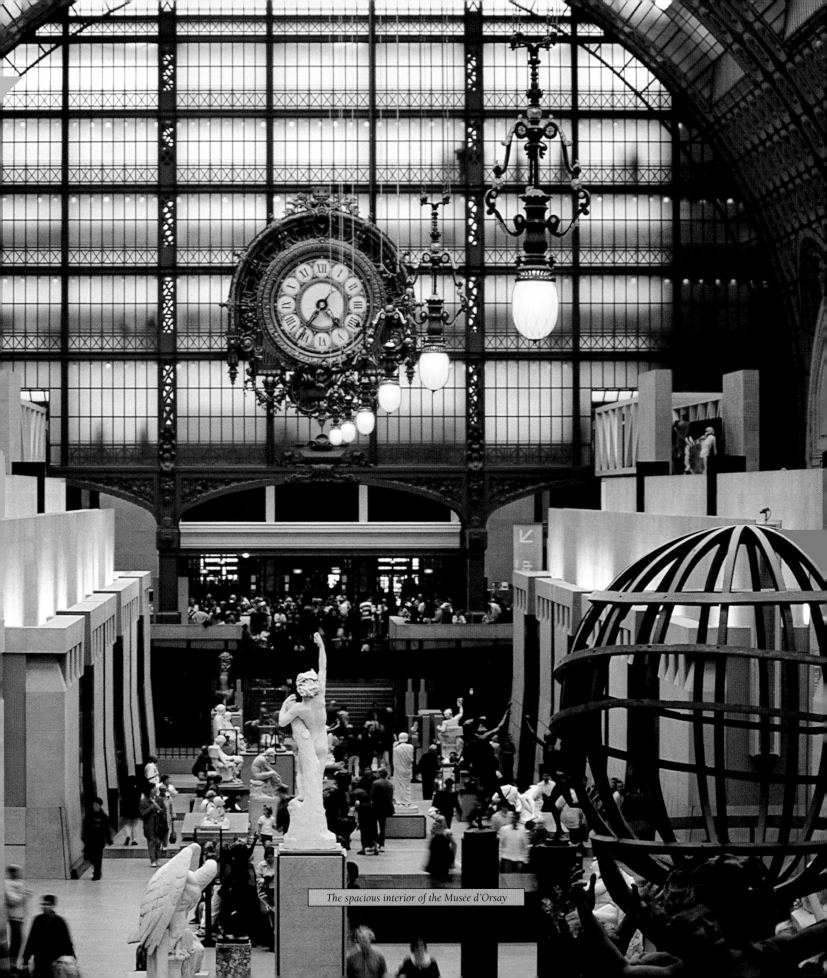
The spacious interior of the Musée d'Orsay

National Museum at the Centre Pompidou (SAWN-truh pawm-pih-DOU), which was completed in 1976. All the working parts of this museum—the pipes, the heating ducts, and even the escalators—are on the outside of the steel and glass building. The Centre Pompidou museum exhibits contemporary art, which

The four-story Weisman Art Museum, in Minneapolis, Minnesota, is an eclectic mix of sharp, irregular angles, curves, and tower-like structures. Architect Frank Gehry covered two sides with "wrinkled" stainless steel to reflect sunset colors like ripples on the adjacent Mississippi river.

includes not only painting and sculpture, but also pieces that use film or video or sound. The museum's design frees up space so that artists can create sprawling experimental artworks, called installations, that wouldn't fit into a traditional museum's exhibition space.

Until the 20th century, most museums were built with majestic columns and imposing entrances intended to associate the building and its contents with great historical periods of art and learning. The Metropolitan Museum of Art in New York City and the British Museum in London are examples of buildings that remind the viewer of Greek and Roman temples.

The first Smithsonian Institution building was designed in a medieval style. The architect, James

The National Museum at the Centre Pompidou

Renwick, Jr., wanted to evoke the scholarly atmosphere of the great British universities. Built in 1855, this building—now known as the Castle—contained an art gallery, a lecture hall, chemistry and natural history laboratories, and a science museum. Today it houses the Smithsonian's administrative offices and is one of the most recognizable buildings in Washington, D.C.

The expansion of the Smithsonian Institution illustrates how museums and their needs have changed in the last hundred years. The Smithsonian is now the world's largest museum complex. It houses 140 million objects, artifacts, and specimens in 16 museums, the National Zoo, and many research facilities in the United States and around the world. The Smithsonian's museums include the Natural History Museum, the National Air and Space Museum, the

The interior of the Smithsonian's Arts and Industries Museum

Arts and Industries Museum, and nearly a dozen art museums. Among the art museums, the National Gallery of Art, the National Museum of African Art, the Sackler Gallery of Asian Art, and the Hirshhorn Museum and Sculpture Garden are especially significant architecturally.

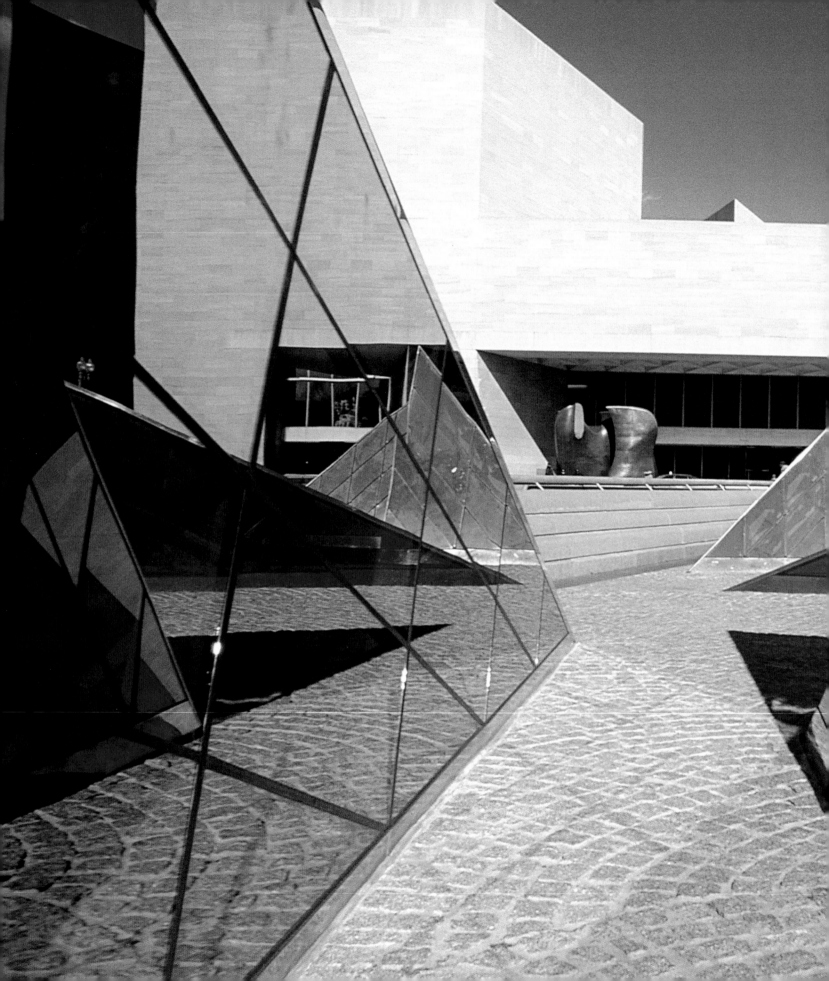

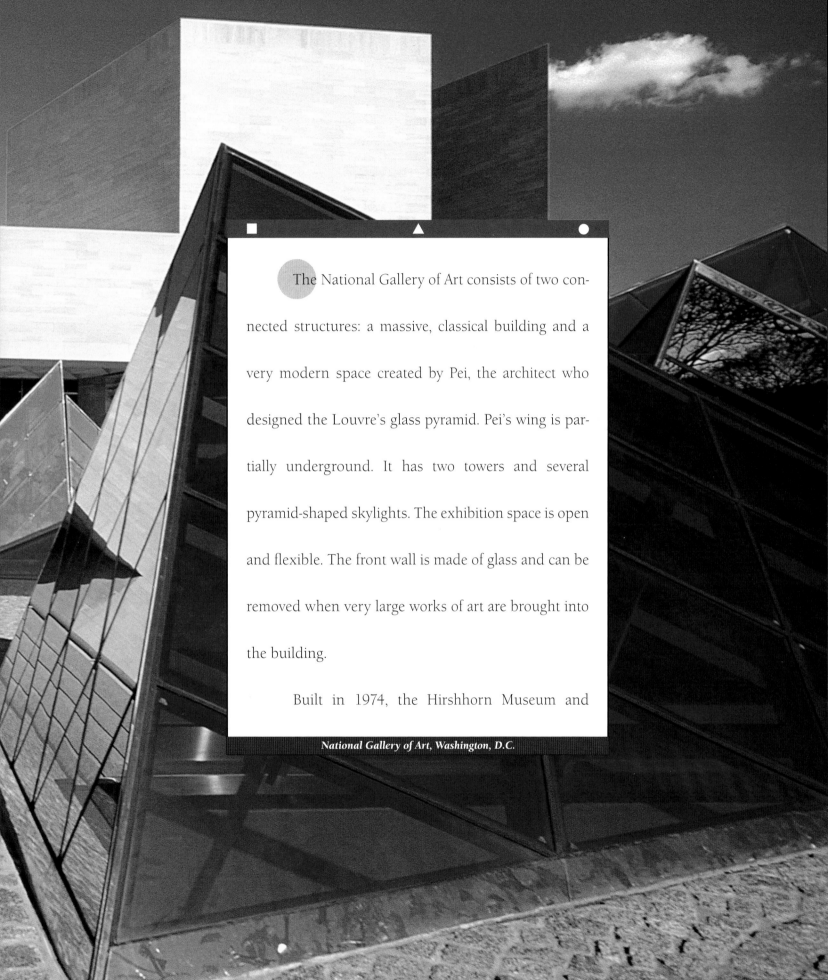

The National Gallery of Art consists of two connected structures: a massive, classical building and a very modern space created by Pei, the architect who designed the Louvre's glass pyramid. Pei's wing is partially underground. It has two towers and several pyramid-shaped skylights. The exhibition space is open and flexible. The front wall is made of glass and can be removed when very large works of art are brought into the building.

Built in 1974, the Hirshhorn Museum and

National Gallery of Art, Washington, D.C.

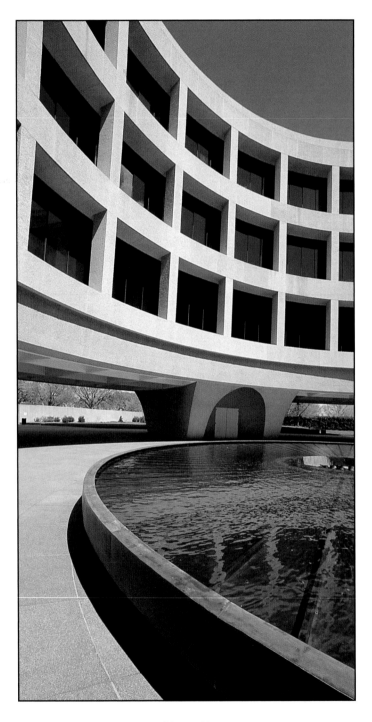

Sculpture Garden is a four-story concrete cylinder supported by four piers. The curving concrete piers contain the building's elevators, stairs, plumbing, and wiring. The windows on the circular inner wall allow visitors to look down on sculpture and a fountain.

Although the National Museum of African Art and the Sackler Gallery of Asian Art look very different, each has a floor plan that resembles six milk cartons arranged in a rectangle that is two squares long

The curves of the Hirshhorn Museum

LIVING MUSEUMS

A living history museum can be a farm, a fort, or an entire village. The museum's staff recreates the past by re-enacting the daily work and life of a particular time and place.

and three squares wide. The National Museum of African Art has six identical domes, while the Sackler Gallery of Asian Art has six identical peaks. The exterior design and decoration of each building reflects the architecture from the part of the world from which each museum's collection comes.

One of the busiest museums in the Smithsonian complex is the National Air and Space Museum. It contains the world's largest collection of historic air- and spacecraft, including the Wright brothers' 1903 flying machine; Charles Lindbergh's *Spirit of St. Louis*, which was the first airplane to be flown by a solo pilot across the Atlantic Ocean; and the *Apollo 11* command module from the first moon landing. When an additional building opens in 2003, visitors will be able to watch the museum staff restoring historic aircraft.

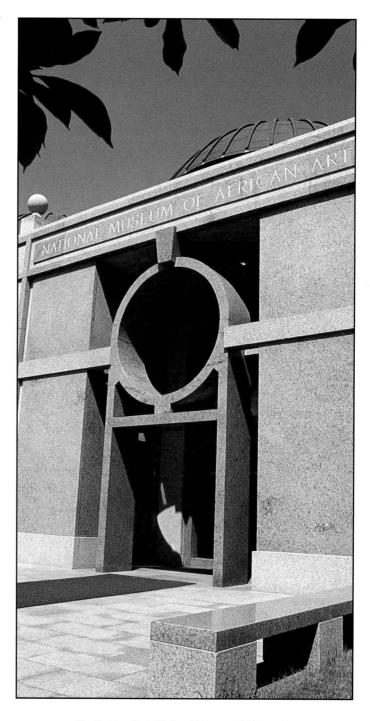

The Smithsonian's National Museum of African Art

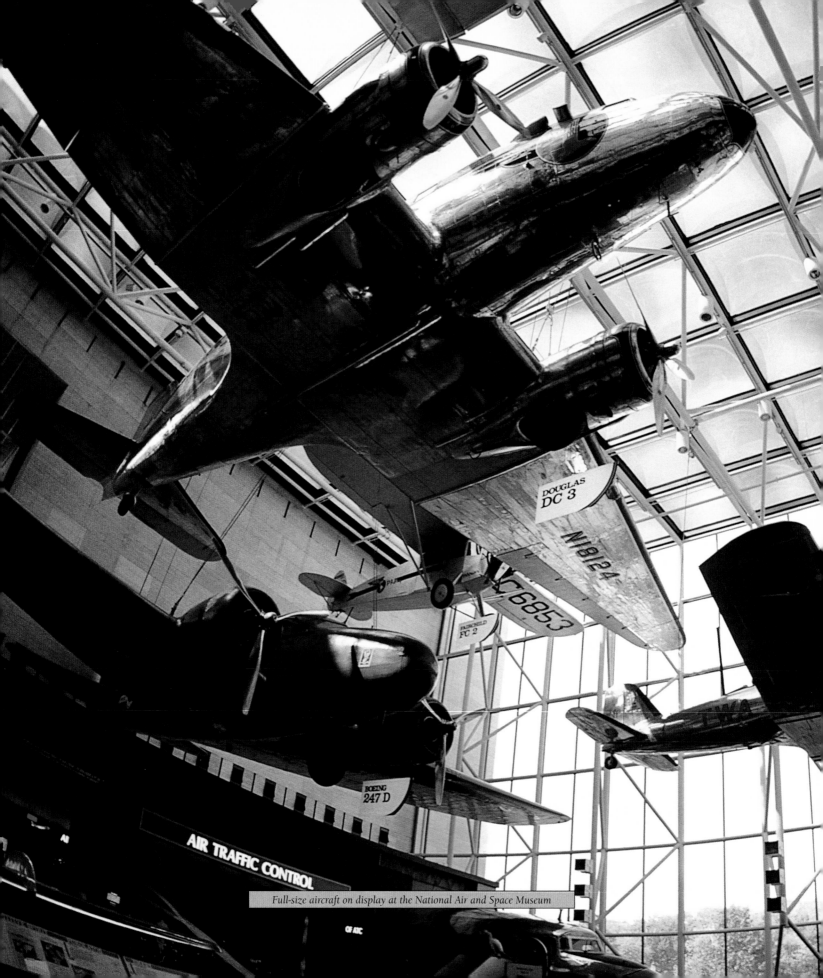

DOUGLAS
DC 3

N18124

NC6853

FAIRCHILD
FC 2

BOEING
247 D

AIR TRAFFIC CONTROL

Full-size aircraft on display at the National Air and Space Museum

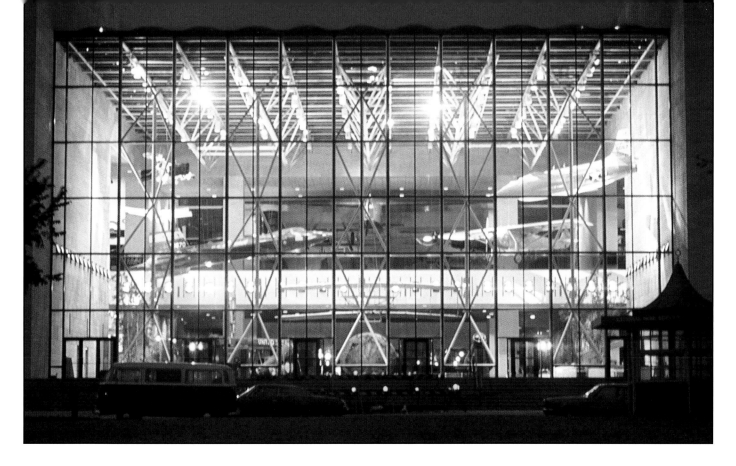

A large glass wall of the National Air and Space Museum

This new branch of the National Air and Space Museum will be designed like an airplane hangar but will be made of glass and have ramps, elevators, and walkways that allow visitors to get close to aircraft hanging from its ceiling.

At any one time, most museums have room to exhibit only a small fraction of the objects they own, and some objects, such as vegetable-dye textiles or historic Japanese wood block prints, are so sensitive to light and so fragile that they can be displayed only for a short time. Therefore, in addition to making sure that the work on display is safe from damage and theft, most museums

The Arizona-Sonora Desert Museum is an open-air museum located near Tucson. It explains the desert's ecology through exhibits of plants and animals. The museum's geological exhibitions are housed underground in a structure designed to resemble a limestone cave.

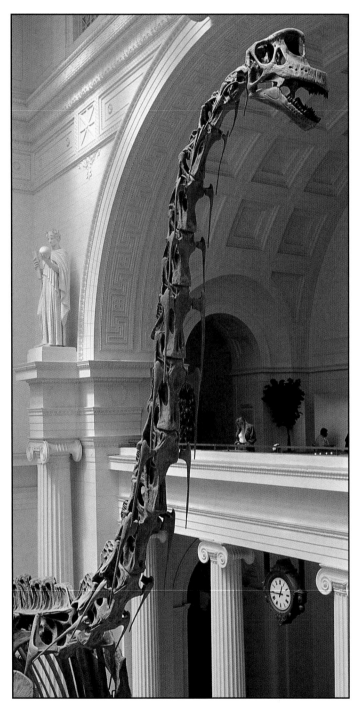

A dinosaur exhibit in Chicago's Field Museum

have to maintain secure and carefully ventilated storage space for thousands of objects. Although these items are not available to the general public, scholars and researchers are often allowed to view them.

Other spaces in museums that are not usually seen by the public include a place to keep records about each item in the museum's inventory; a research library for the staff and visiting scholars; a conservation laboratory where objects are cleaned or repaired; and workshop areas for designing and building exhibitions and for packing and unpacking objects.

In addition to serving scholars and researchers, modern museums also work hard to attract all kinds of people. In the United States, more people visit museums each year than attend professional sports games. Today's exhibitions often try to strike a balance

between entertainment and education. Special exhibits can be major tourist attractions. For example, in 1999, an exhibition of paintings from the Van Gogh Museum in the Netherlands brought thousands of visitors to Los Angeles. In 2000, when Chicago's Field Museum of Natural History unveiled Sue, the largest and most complete *Tyrannosaurus rex* skeleton in the world, there was live television coverage. Viewers all over the United States and Canada learned about the painstaking excavation and reconstruction of the skeleton of this extinct creature.

Many museums offer lectures and classes for learners of all ages. Accessibility for wheelchair users and blind or deaf visitors has become increasingly important as museums try to include more people in their audiences. For example, the Smithsonian's

A painting by Willem Vincent Van Gogh

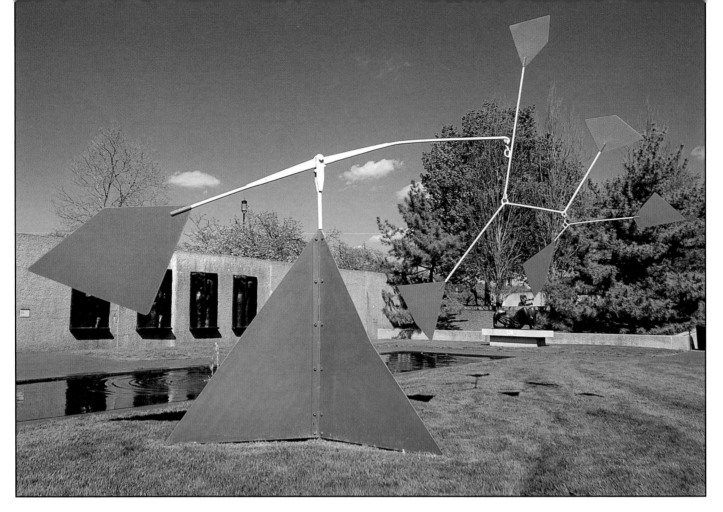

Hirshhorn Sculpture Garden art

Hirshhorn Museum conducts special "touch tours" of sculpture for visually impaired visitors. Large museums may also be social and commercial gathering places. People are welcome to visit a museum just to shop in its gift store or eat in its restaurant. Some new museums have IMAX movie theaters as well as space that can be rented for banquets and receptions. Major museums are becoming increasingly important to the social and economic health of cities.

Sometimes a museum's architecture is actually its primary attraction. The Guggenheim Museum has a history of influencing architecturally innovative buildings. Frank Lloyd Wright, an architect known for his interest in using new materials and creating open

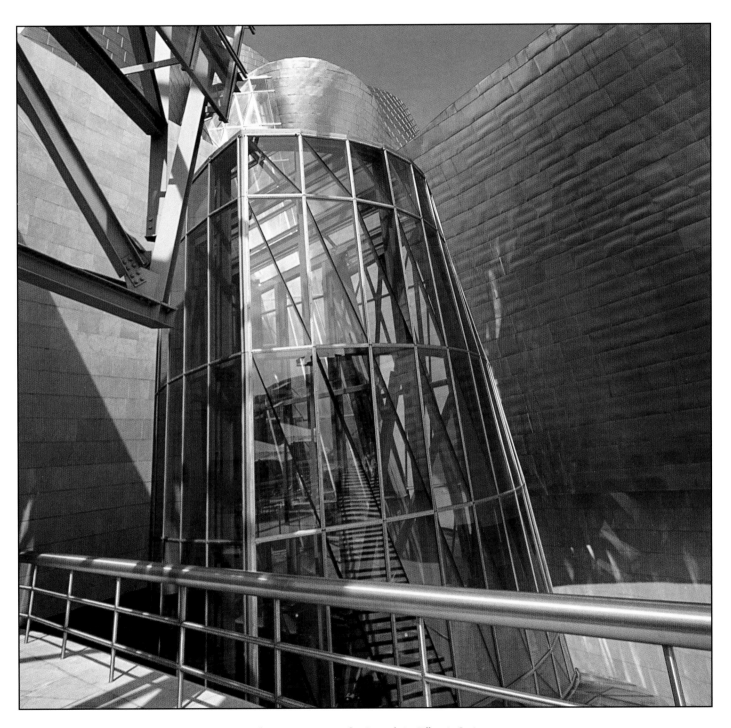

The main entrance to the Guggenheim Bilbao in Spain

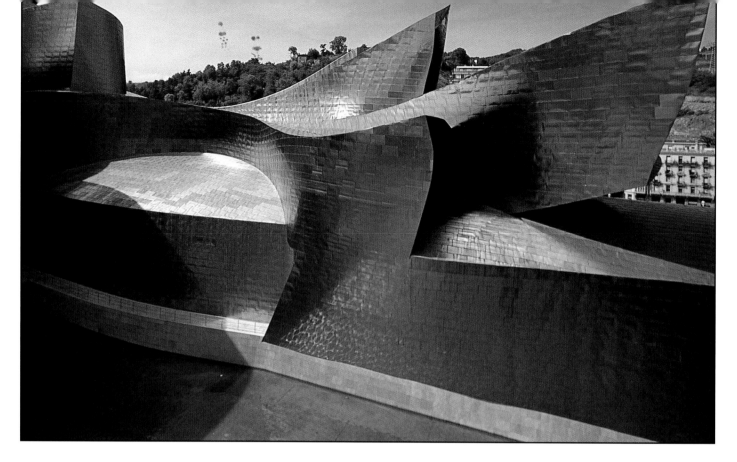

The non-traditional look of the Guggenheim Bilbao

spaces without interior walls, designed this spiral art museum that opened in New York City in 1959. The main gallery is a continuous winding ramp. In 1998, a branch of the Guggenheim Museum opened in Bilbao, Spain. Guggenheim Bilbao was designed by Frank Gehry, who, like Wright, reimagined what a museum could look like. Gehry envisioned the entire building as a curving metallic sculpture. This shining new museum has put this previously little-known city on the international culture map.

The latest Guggenheim venture is a virtual museum that will exist only in cyberspace. Once visitors are

Mount Aso's volcano museum, in Japan, is located on the ancient rim of the world's largest volcanic crater. Cameras continuously monitor a small active volcano, so visitors can safely watch eruptions in progress on video screens.

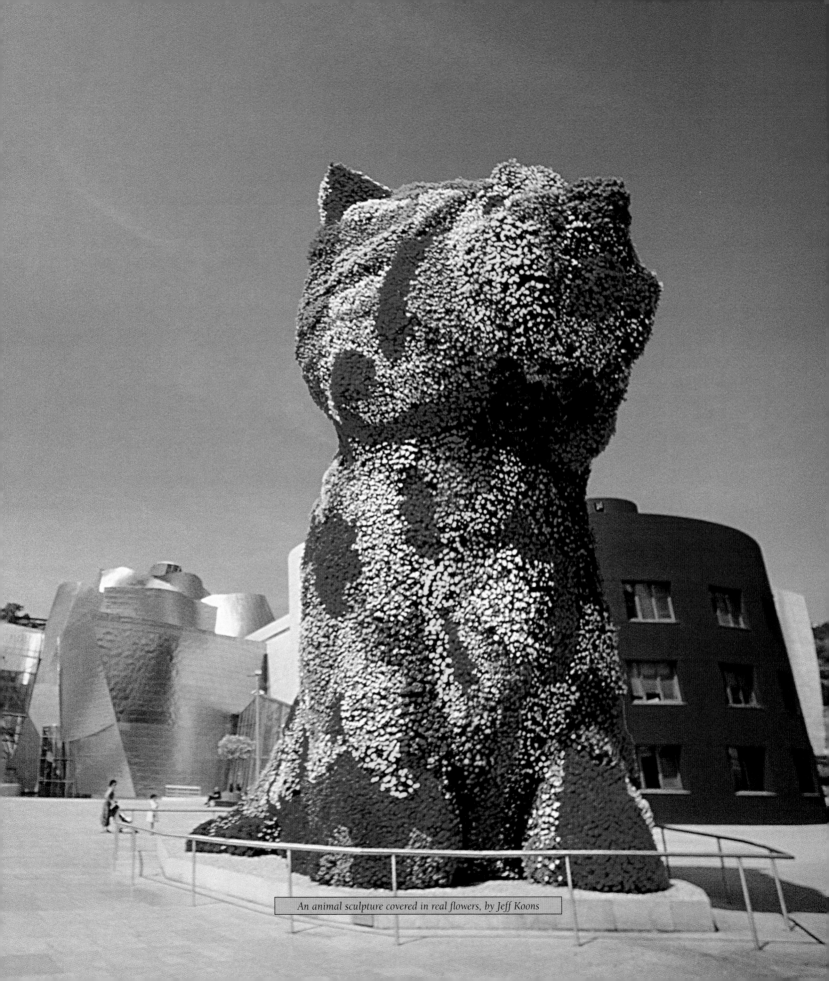

An animal sculpture covered in real flowers, by Jeff Koons

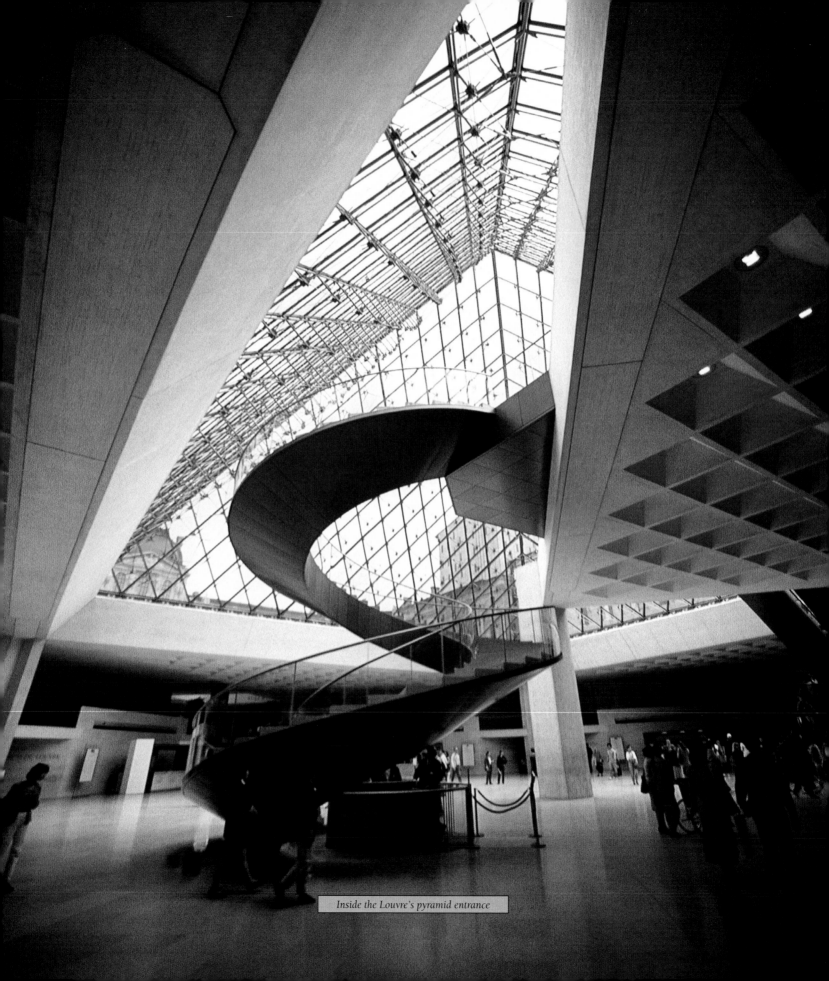

Inside the Louvre's pyramid entrance

online, they will explore a virtual building where the viewing space is constantly morphing, or changing.

With the development of the Internet, the very idea of what a museum is seems to be expanding. People can now visit some museum Web sites and take virtual tours of buildings and collections. Within museums, special computer stations enable visitors to get in-depth information about the items that interest them. The museum is no longer simply a physical

W A X M U S E U M S

Madame Tussaud's Wax Museum has fascinated visitors ever since its founder set up shop in London in 1835. Born in France in 1761, Madame Tussaud first exhibited models of the nobles who were beheaded during the French Revolution.

Open, well-lit design of Chicago's Field Museum

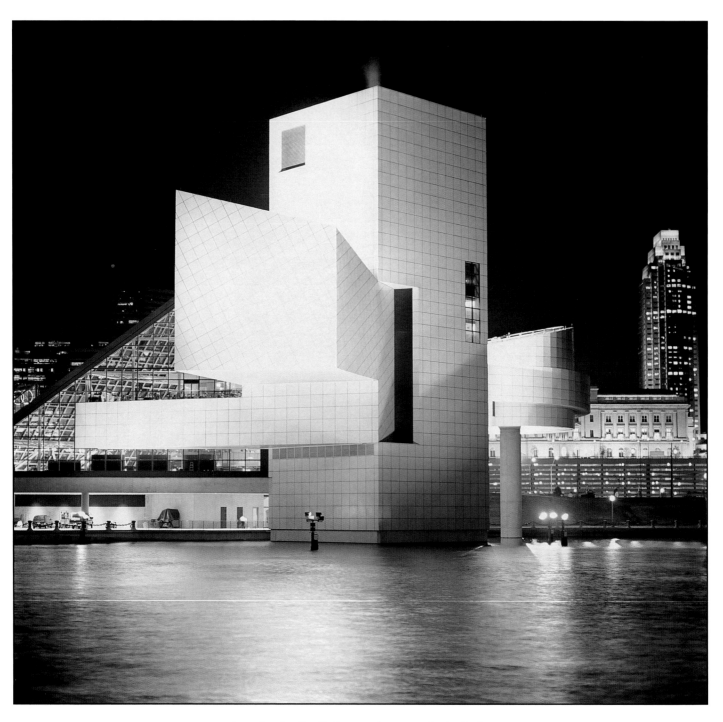

The Rock and Roll Hall of Fame and Museum, Cleveland, Ohio

Olympic flame and museum in Ouchy neighborhood of Lausanne, Switzerland

place to encourage the preservation and study of significant objects. Already a portable museum of scouting memorabilia exists—a museum with no space of its own. Another museum, instead of preserving the art it exhibits, refuses to keep anything more than 10 years old.

The possibilities for future museums are limited only by the boundaries of the imagination. One day soon, people may visit a virtual art museum of cyber-sculpture, or a history museum of science fiction creatures. Because the very idea of a museum is still changing and expanding, no one can say exactly what a museum is or can be. One thing is clear, however; museum designs are—and will continue to be—among the most impressive designs in the world of architecture.

I. M. Pei designed the Rock and Roll Hall of Fame and Museum in Cleveland, Ohio. Like his addition to the Louvre and to the National Gallery of Art, this building features light-catching glass skylights.

I N D E X